# DALE CHIHULY

the icicle creek chandelier

**DALE CHIHULY**

ICICL

# ES

## the icicle creek chandelier

*An outdoor glass installation at Sleeping Lady Retreat
and Conference Center in Leavenworth, Washington*

PORTLAND PRESS | SEATTLE

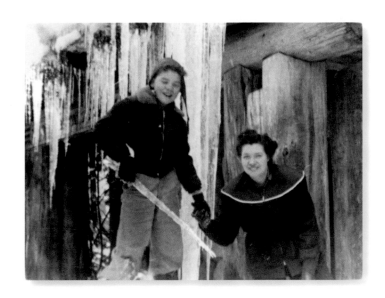

*Dale Chihuly with his mother, Viola Chihuly.*
*Paradise Lodge, Mt. Rainier, Washington, 1952*

›› THERE'S NO DOUBT IN MY MIND THAT WE CAN DO THIS PROJECT, THAT WE CAN DO AN INCREDIBLE P

HREE WEEKS. IT'S GOTTA BE IN RIGHT BEFORE CHRISTMAS OR RIGHT AFTER CHRISTMAS. THERE'LL BE A LOT OF VOICE MAIL. «

NOVEMBER 29 > 6:47PM > CHIHULY

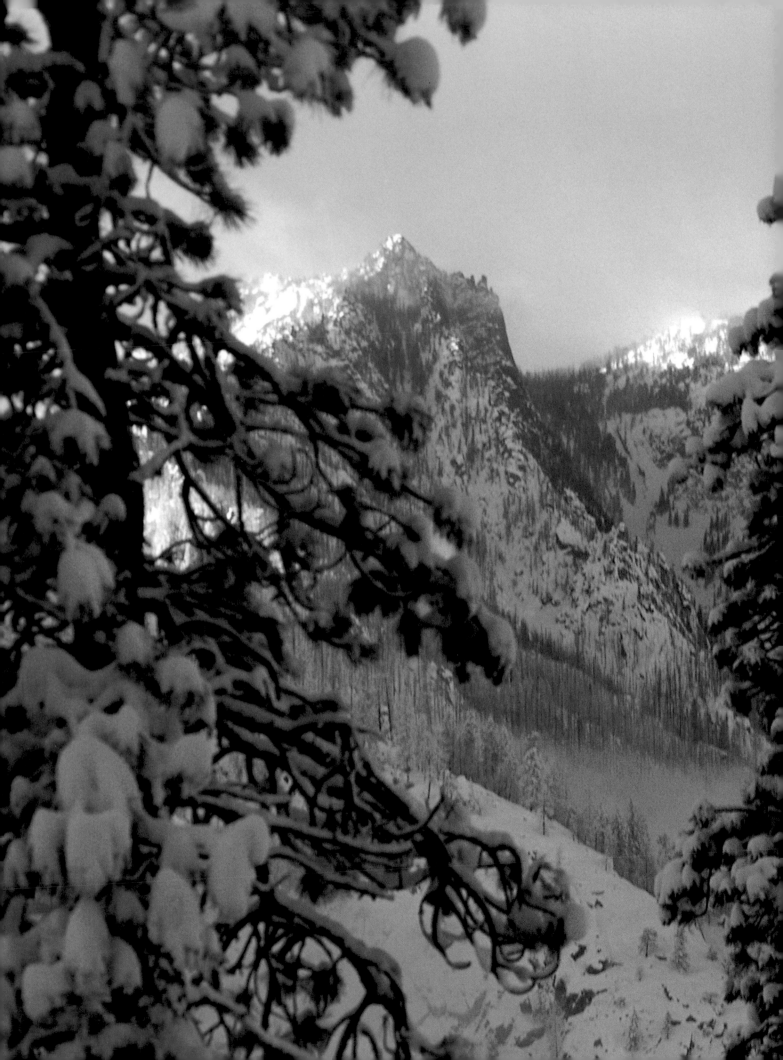

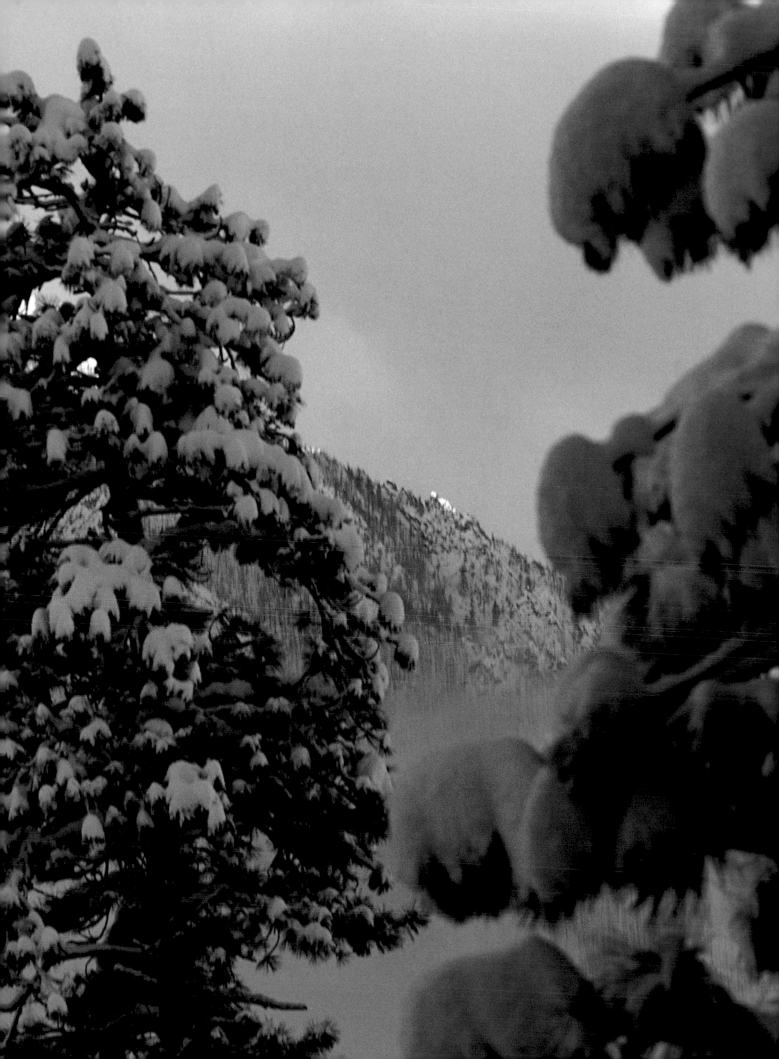

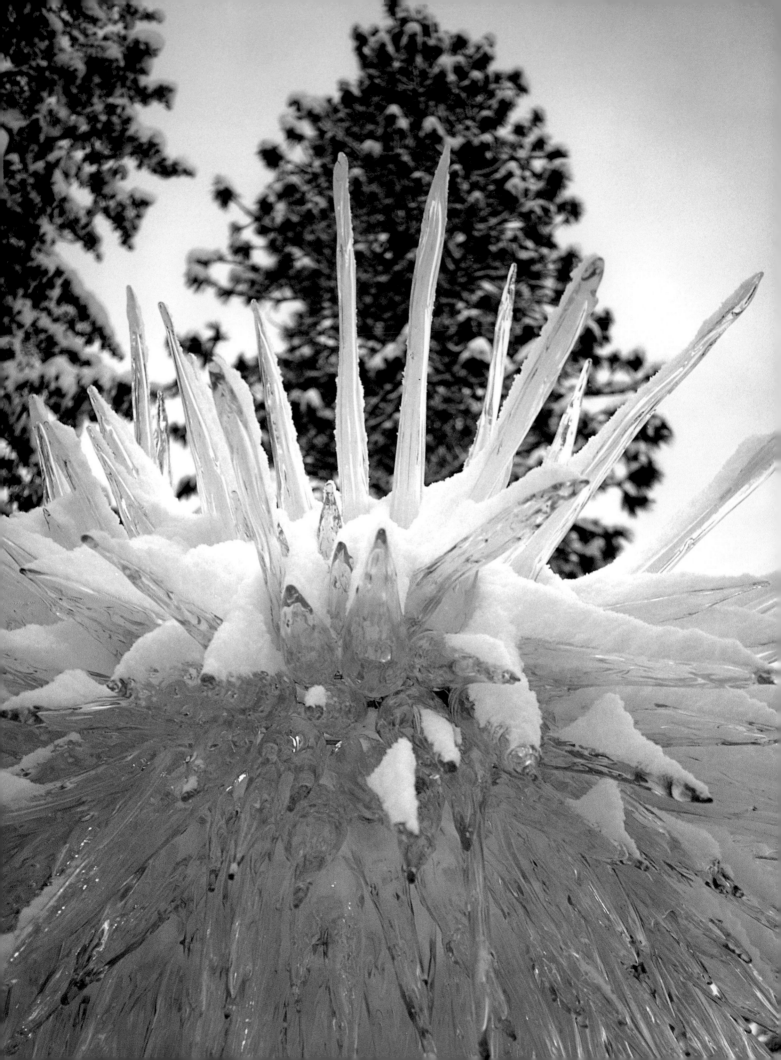

# FOREWORD
### *by Harriet Bullitt*

WHEN I ANSWERED MY OFFICE PHONE AT SLEEPING LADY on the day after Thanksgiving, I was surprised to hear the voice of Dale Chihuly saying, "Hello, Harriet. When I got up this morning I decided I would come over to see the place. Want to walk around and have another look. Changed my mind about the glass piece — thought about the project during the Venice trip and I have a new concept. Do you have any stumps on the place?"

I hadn't heard from Dale for months, in all the time he was busy mounting chandeliers all over Venice, and now he was driving his pink truck down the winding mountain road east of the Cascades, seeing the road with his one eye, and talking to me on his cellular phone.

The 45-minute conversation that followed held clues to what would become the first all-season outdoor masterpiece of its kind in handblown glass. "Stumps or big rocks — it needs the right base. I've decided not to do a piece inside the chapel after all; it will be outdoors and look like a tree, upside down, made of icicles.

"Sleeping Lady's the right place. Where it belongs. This will be the test site."

The advent of Dale Chihuly with his gift of glass art was a serendipitous event, just as the start of Sleeping Lady was. This resort and conference retreat lies just outside Leavenworth, Washington, at the base of Icicle Canyon on the east side of the Cascade Mountains. The Yakima Diocese of the Roman Catholic Church had owned the site most recently, where a gentle Irish priest, Father Joseph O'Grady, ran a kids' camp in the 1960s and 1970s. Before that, it had been a dude ranch and, in the 1930s, a Civilian Conservation Corps camp, whose men built the original board and batten buildings. Previously the land pastured horses and was farmed by early homesteaders. Until the influx of white settlers, all the land around the site was the gathering place for thousands of Indian people who lived on the rich abundance of salmon from the Wenatchee River and Icicle Creek.

It was a shock when, in 1991, an agent of the Yakima Diocese came to me to

say, "The camp has to be sold. Since your property adjoins it, are you interested?" Across Icicle Creek lay the land of my happiest childhood times, from the early 1930s, and part of every year since. I scrambled all over these wooded hills and in the canyon; swam in the flowing water; slept under the stars; and became forever bonded to this magical space. My children and grandchildren are part of it now.

As a vision of what could happen to this land flashed through my mind's eye, a sense of destiny took over. Since I had recently sold my businesses on the coast, retired a debt, and moved to the valley that I loved, the decision to acquire was swift. But then, what to do with 67 acres of wild land, 18 dilapidated cabins, a failing business, and a beautiful stone chapel? It had to be redeveloped in some way. Having been harshly critical of developers and the construction industry for damaging the land with wasteful and unsightly practices, what could be built that would harmonize, not clash, with nature and yet sustain itself economically? And to what purpose?

Looking up to the forested ridges and pondering the accelerating losses of our natural heritage to the relentless pressures of human expansion, I wondered if there might be a way to share this place with small groups of people to gather and find refreshment from contact with nature and new perspectives on themselves and others. Could the place inspire activism toward a more simplified lifestyle?

There is a serenity to this land that touches the spirit. The grandeur of the pines, the ancient granite boulders, the ever-changing river, and profusion of wildlife nourish the soul and make one feel protected — at home. What could be done here that would disturb the harmony as little as possible and yet invite people to convene in comfort and joy?

I made plans to redevelop the old buildings into an environmentally friendly retreat center named Sleeping Lady after the mountain profile floating above the narrow valley. I thought that people solving problems together should have more fun. They do not need austere conditions and hairshirt attitudes; they deserve to celebrate their work. To begin with, I decided, the best food, beds, and service were essential, provided in human-scale buildings that would blend with the land.

The other need was for beauty — to see, hear, and feel what is already offered by nature. The only enhancement that humans can add is art. When we are surrounded by beautiful architecture, music, and art, created by fellow humans and blended with nature, we feel a sense of groundedness, of belonging to a community, which inspires us to stretch and see a purpose to human existence.

If a resort experience could relieve the urban strain of separation from nature, and make us proud of our species for a moment, then maybe visitors would leave

Sleeping Lady with a new sense of hope and a promise to make their world back home a better place. That became Sleeping Lady's mission.

From planning to completion in 1995, the entire focus throughout design, construction, and finally staffing has been to provide a serene space for guests to think and play creatively, leaving with an enriched relationship with nature, other people, and themselves. Conservative environmental practices were the mandate. To avoid filling landfills, we simply moved the old cabins to new locations on the site and reused as many materials as practical. We ground up unusable wood and sheetrock to spread a limy mulch on the organic garden-to-be. New cottages repeated the look of the original, remodeled ones to recall the history of the 1930s. We bought as much recycled new

 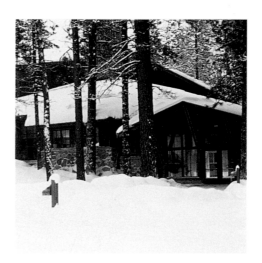

material as we could, preferring low-energy cost of manufacture. Wind and winter sun do not prevail at the site for power sources, so we chose electricity, targeting conservation through quality materials and commonsense techniques, many of which would tend to enhance rather than reduce guest comfort.

New sleeping cottages are clustered around courtyards so that guests can find each other. Outdoor paths wind among the cottages and several meeting lodges of various sizes. The pools, library, sauna, central dining hall and terrace, grotto bar, fire circle, and river meadow all invite formal or impromptu get-togethers. The naturally elegant sleeping rooms and freshly prepared food, with vegetarian choices, seafood, and lavish desserts, enhance the opportunity for relaxed creativity.

If the first surprise was acquiring the place, the second was witnessing the contributions of artists along the way. We did not set out to collect artworks. Talent emerged from the valley. Pieces of art and sculptural features appeared, many created by workers

on-site and integrated into the construction. The Icicle Creek Music Center was formed around what had been a chapel, now converted to a theater, because of its fine acoustical quality and intimate, spiritual space. Outdoor music from the summer chamber festival mingles with the songs of birds and falling water.

The ultimate crown jewel was yet to appear. When I first knew Dale, he had visited our home at Icicle Creek, having opened a glass exhibition in Wenatchee. He brought toys for the children, coached us all in frisbee, and took walks with me around the site. A conversation followed about what a dream it would be to have a Chihuly chandelier in the ceiling of the theater reception gallery — maybe in a couple of years. After many months passed, we finally decided to go ahead with it. Measurements were taken, and tentative plans made. More months passed. The next time I heard Dale's voice was from his car on the way over the mountains.

We were still talking when his car pulled up by my office. He trudged around under the trees, and near the path by the theater, beneath the mountain profile of the Sleeping Lady, he picked the biggest boulder on the place and said, "That's the place. The chandelier will be clear glass — no colors — because the sun and the outdoors will give it ever-changing colors."

At Christmas time, 20 degrees below zero and snowing, Chihuly's crew of ten worked for two days tying 1,200 glass icicles atop that boulder. Now whether illuminated by the sun, moon, or lights from nearby trees on a dark night, it sparkles like a living presence from the forest. Some people see it as a fountain erupting, others as a shining entity alighting. We have even been asked what we will do when the sun warms it!

This book describes the practical process by which the mystical genius of Dale Chihuly reveals itself. Seeing how the Icicle Creek chandelier was made only heightens the sense of wonder one feels at viewing this startling piece. It is a permanent reminder of how a human-made creation can be framed in nature and find harmony within it.

*Dale Chihuly and Harriet Bullitt, December 1996*

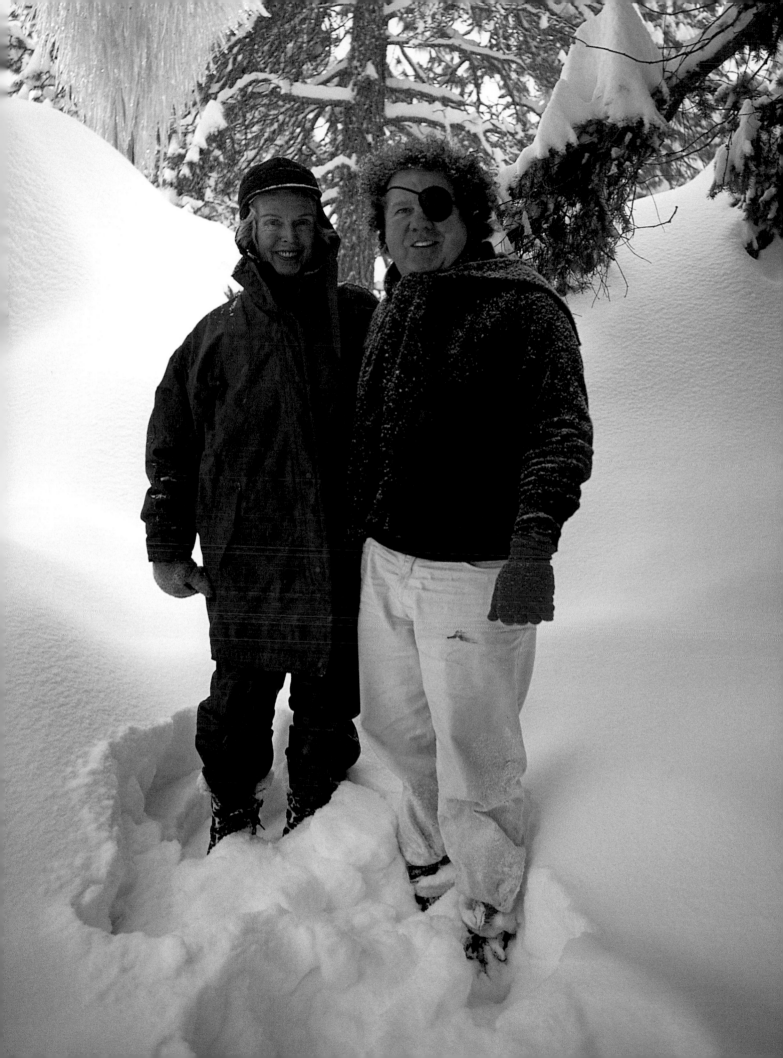

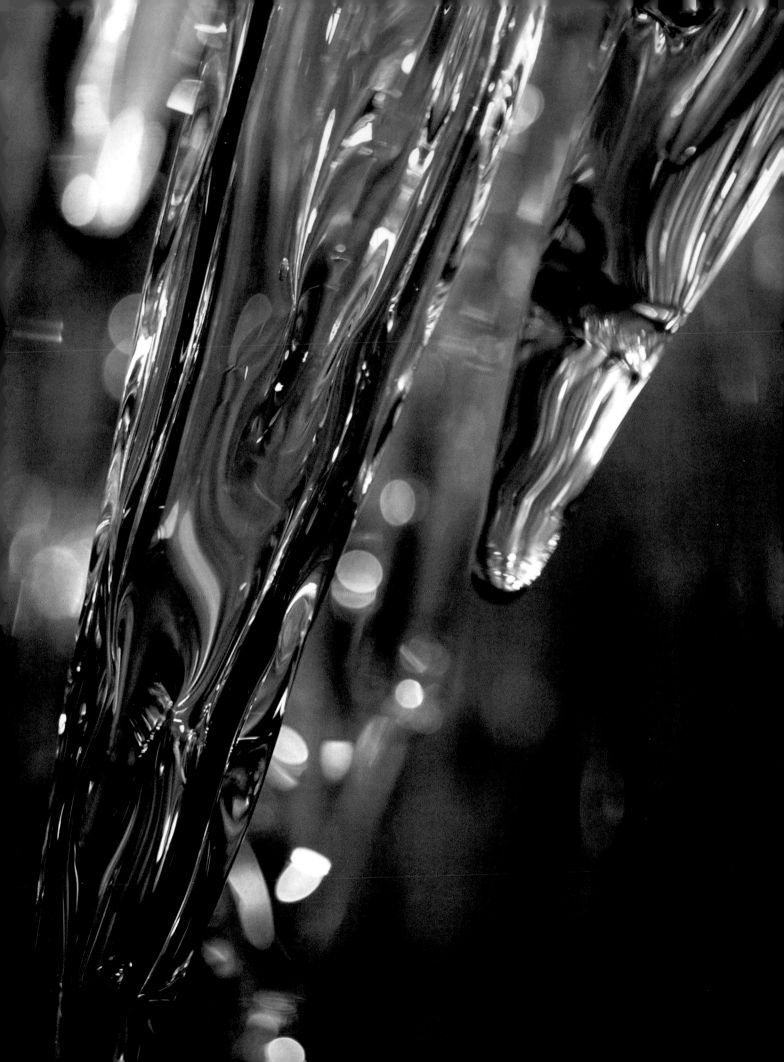

# THE STORY OF A GLASS CREATION

*by Wilfred R. Woods*

YOU ALWAYS WONDER HOW CREATIVE THINGS HAPPEN. I am reminded of that after watching the Dale Chihuly glass "chandelier" being assembled last month at the Sleeping Lady Conference Center. How did it all come into place?

For one thing, it didn't start out as an outdoor piece, the first of its kind. Harriet Bullitt told us that Chihuly had stayed at her center in the summer of 1994, when he had brought his display of glassware to the North Central Washington Museum. He stopped overnight at the Sleeping Lady center while it was still in its state as a church retreat before she had started its renovation.

The Camp Field stone chapel was where she visualized one of his glass artworks, and they agreed on that idea. Chihuly had not done any work on what is now called the Salmon Gallery. But last fall he was en route to the center over Blewett Pass and called her on his car phone with a new idea.

Why not erect an outdoor exhibit, he said, and he visited with her on the phone until actually driving into the place. She agreed with the change in concept, and he immediately put his staff to work. Chihuly had done some large outdoor glass sculptures for a show in Venice, hung over canals and in public places.

Within a few weeks of his visit to Leavenworth, his crew of glassblowers was at work blowing a thousand glass icicles. they erected the glass sculpture on a metal framework in Chihuly's shop before boxing up the whole lot and trucking them to Leavenworth. Kathy and I watched his crew of a dozen people reassemble that one-ton, 10-foot-high dazzling piece of glasswork on top of a huge boulder next to the dining hall at the center.

Chihuly himself came to the unveiling fresh from a trip to the Far East with a busload of his staff and friends in time to get snowed in at Leavenworth. He finally got out after a couple of days by chartering a plane from Wenatchee, but some of his busload were there for the week.

What a climax for an unveiling!

*Reprint of an article published February 7, 1997, in* The Wenatchee World

Venice 5·29·96

CHIHULY STUDIO 509 NE NORTHLAKE WAY SEATTLE, WA 98105
TEL: 206 632 8707 FAX: 206 632-8825

Dear Harriet

Greetings from Venice - we're making arrangements for hanging the chandeliers - we'll miss you in September, but we can come to sleeping today in October! I'd be happy to give a talk or show the Chihuly Over Venice video or whatever! Start selling tickets for the drawing now!

As far as the Chimney for the Chapel goes, I think it should cover or extend throughout much of the gallery. I would like to build it full scale in my studio or have you come & look at it or discuss it with me. I'm sure I can make you a wonderful chandelier totally unique ceiling / chandelier sculpture - it would be a honor - a pleasure & a lot of fun.

xoxo Ever
your
Chihuly

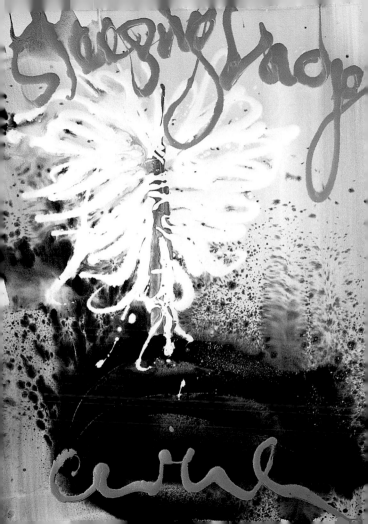

›› I WENT OVER TO LEAVENWORTH FRIDAY AND SITED THE PIECE ON A BIG ROCK THAT GETS SUNLIGHT FROM ALL DIRECTIONS BETWEEN THE DINING HALL AND THE CHAPEL .

YOU CAN SEE THE RIVER FROM THE ROCK. ON THAT, I WANT TO BUILD THIS ARMATURE THAT WE'RE GOING TO DO A TREELIKE PIECE ON. ONLY IT'S GOING TO LOOK MORE LIKE ICICLES. ‹‹

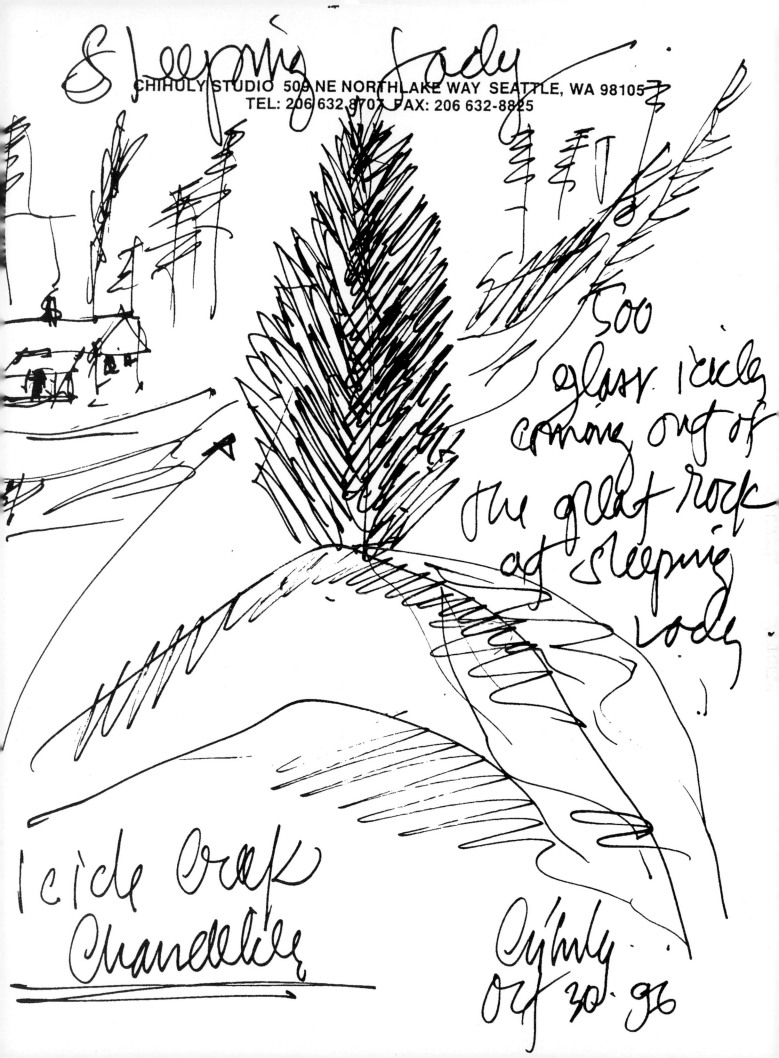

Sleeping Lady

CHIHULY STUDIO 509 NE NORTHLAKE WAY SEATTLE, WA 98105
TEL: 206 632 8707 FAX: 206 632-8825

500 glass icicle coming out of the great rock at sleeping Lady .

Icicle Creek Chandelier

Chihuly
Oct 30 . 96

›› BASICALLY, PARKS, IT'S PRETTY SIMPLE. I CAN EXPLAIN THIS SO YOU PROBABLY DON'T NEED TO SEE A FAX. WHICH IS, YOU'VE G

JLDER 10 FEET HIGH, LET'S SAY 15 FEET WIDE ON THE GROUND. AND THEN IT REALLY HAS A KIND OF RIDGE ON TOP. SO IT'S NOT FLAT. «

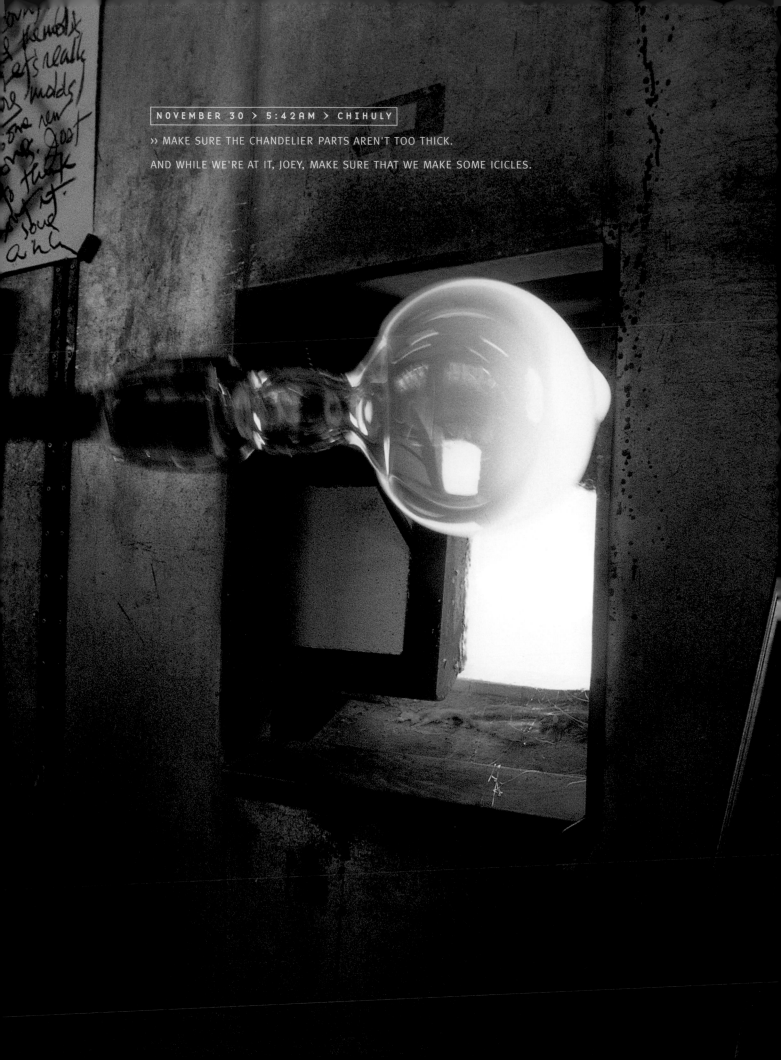

›› MAKE SURE THE CHANDELIER PARTS AREN'T TOO THICK.

AND WHILE WE'RE AT IT, JOEY, MAKE SURE THAT WE MAKE SOME ICICLES.

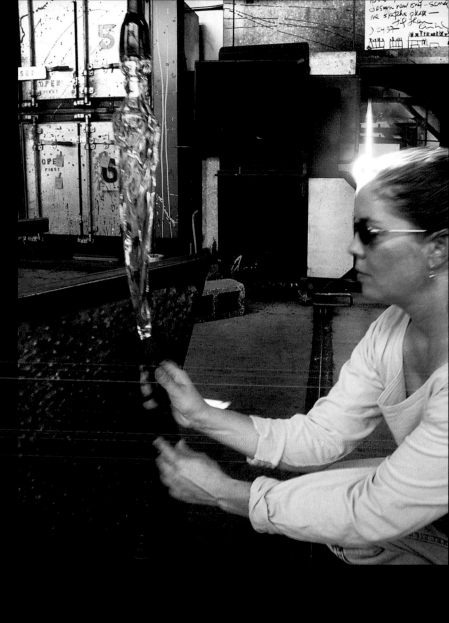

MAKE ME SOME ICICLES THAT ARE EITHER IN OR NOT IN AN OPTICAL MOLD.
MAKE HALF OF THEM OUT. MAKE 10 OF EACH THAT ARE REALLY JUST FOR
YOUR BASIC LONG THING THAT'S NOT BEEN TWEAKED, NOT BEEN CUT, NOT
BEEN POKED, NOT TOO THICK. «

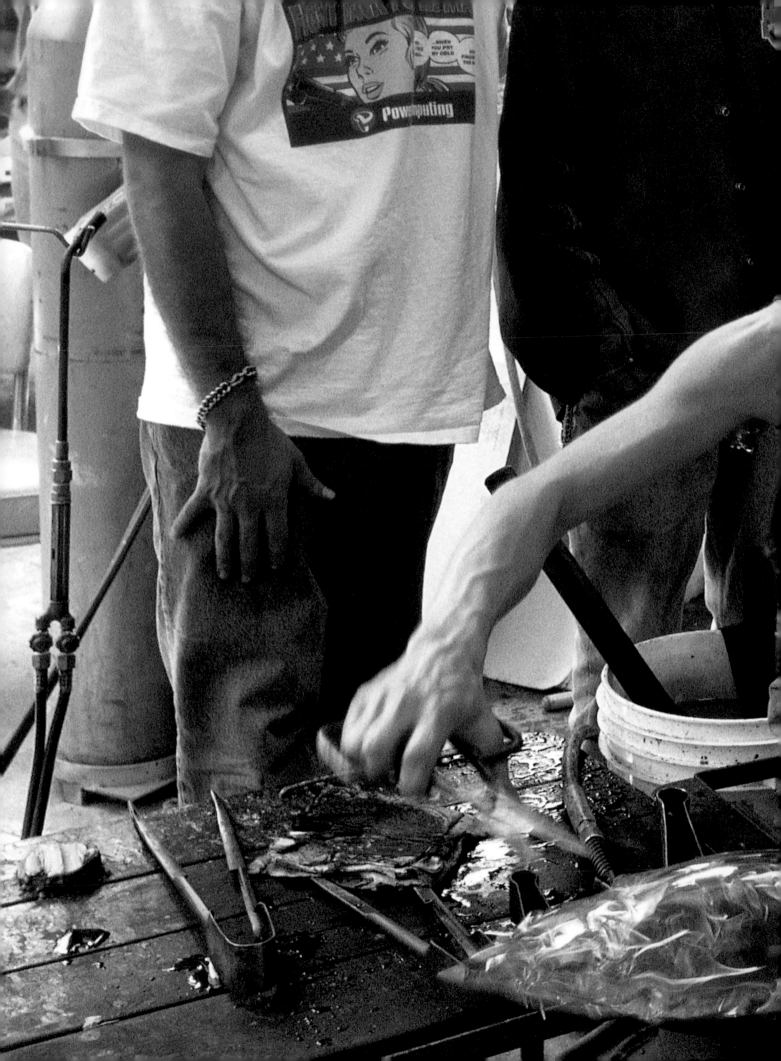

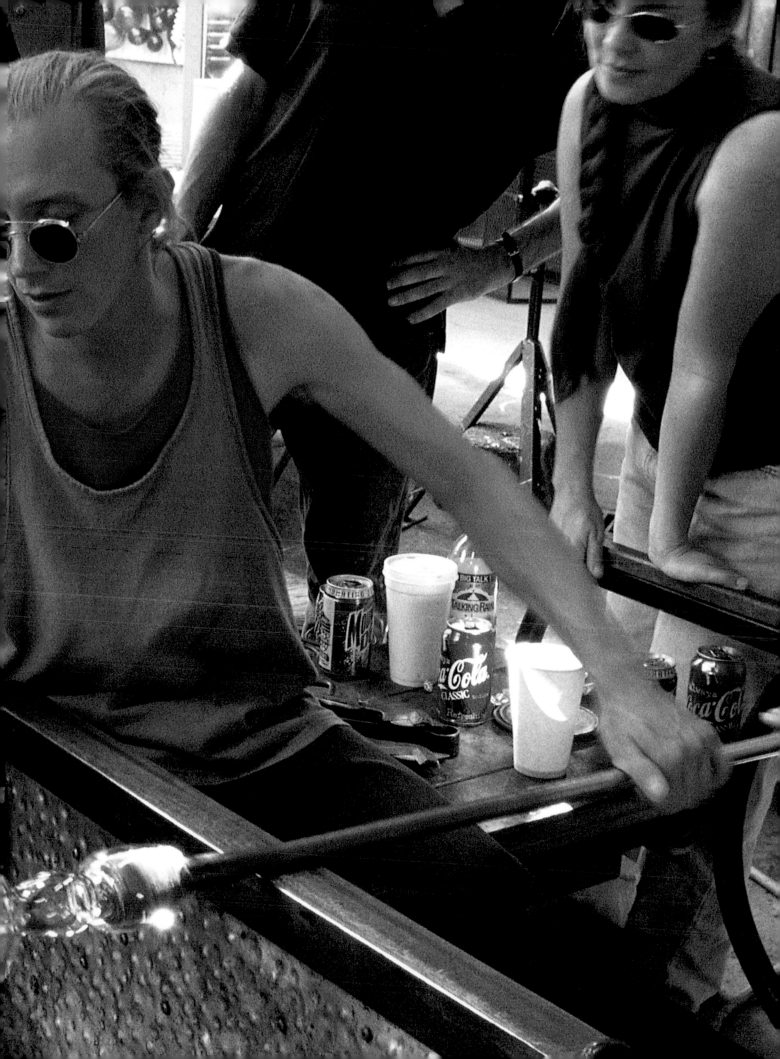

DECEMBER 02 > 8:17AM > CHIHULY ›› SO AS FAR AS THE ARMATURES GO, I TOLD YOU WHAT SIZE TO MAKE THE CHANDELIER, BUT NOT THE ARMATURE. IT WOULD PROBABLY HAVE TO BE ABOUT, OH WELL, MAYBE ONE SHOULD BE 12 FEET WIDE, 18 INCHES HIGH. SOMETHING LIKE THAT. TWELVE FEET HIGH BY A FOOT AND A HALF, AND SAY 3 FEET HIGH. AND LET'S MAKE A SECOND ONE THAT'S, LET'S SAY 7 FEET BY 2 FEET HIGH, WHICH IS CONSIDERABLY SMALLER THAN THE FIRST ONE. ‹‹

DECEMBER 04 > 3:09PM > CHIHULY ›› REMEMBER, THE SEALING OF THESE PARTS ONTO THE ARMATURE IS CRITICAL. THERE ARE MANY WAYS TO SEAL THE PARTS ON THE ARMATURE, AND I THINK WE HAVE TO EXPLORE THE POSSIBILITY OF USING PERHAPS A DOUBLE SYSTEM, WHERE WE PUT IT ON SO IT'S SEALED ONE WAY, AND THEN WE SILICONE AROUND THEM IN AN ADDITIONAL WAY. ‹‹

DECEMBER 07 > 7:35AM > CHIHULY ›› SO YOU'VE GOT TO WIRE THE PIECES ON MONDAY. YOU'VE GOT TO HANG THEM ON TUESDAY AND THEN WIRE THE REST OF THE PIECES THAT COME OUT TUESDAY AND HANG IT. I'M KIND OF SHOOTING FOR THIS PIECE BEING ABOUT 500 PIECES, BUT AS WE DEVELOP THE PIECE, WE'LL SEE HOW MANY IT WILL TAKE. ‹‹

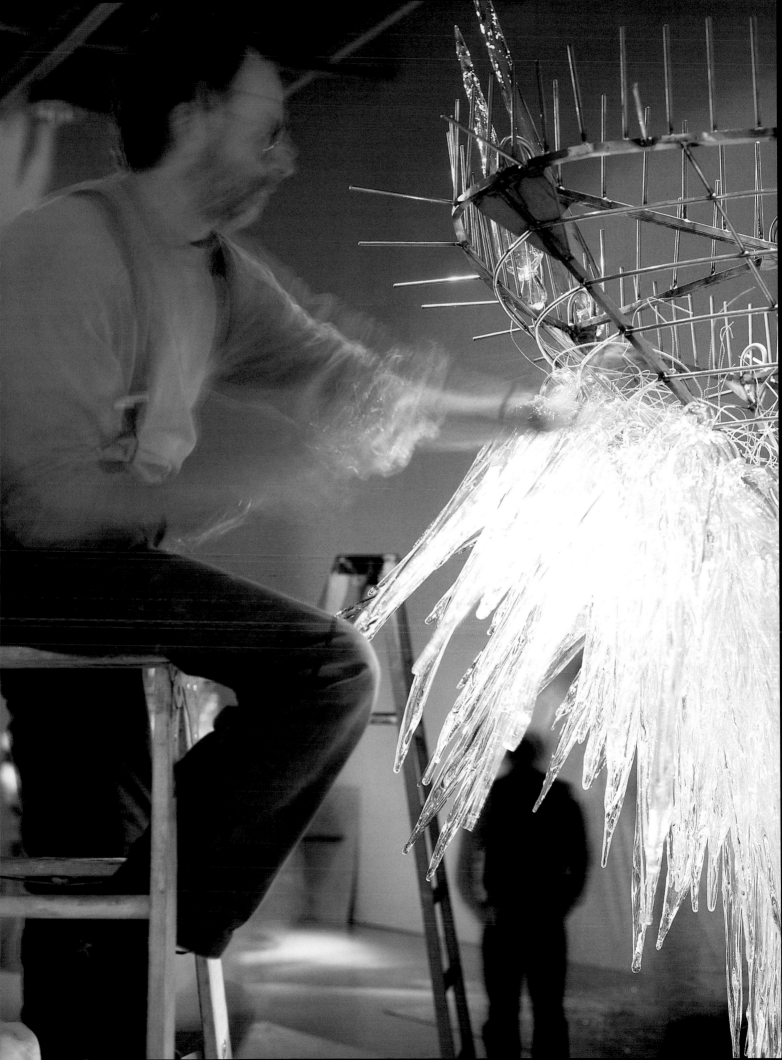

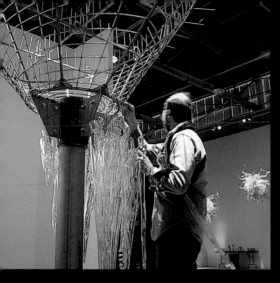
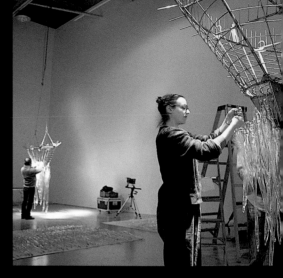
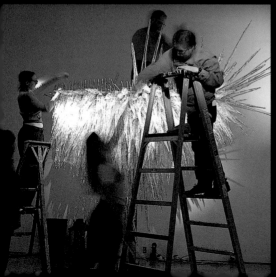
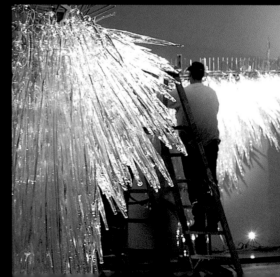

›› HEY KAI, CHIHULY. THIS PLAN SOUNDS GREAT. GOD! YOU GUYS ARE WORKING YOUR BUTTS OFF. I REALLY APPRECIATE THIS, YOU KNOW, ALL-OUT EFFORT TO DO THIS. AND NOT ONLY TO DO IT BUT TO DO IT RIGHT. AND ALSO TO GET IT DOCUMENTED IN THE RIGHT WAY. AND CERTAINLY WE'VE NEVER DOCUMENTED ONE THIS WAY, WHERE WE TAKE ALL THESE PARTS AND GET, YOU KNOW, THREE, FOUR, FIVE, WHO KNOWS? SIX DIFFERENT RENDITIONS OF IT. ‹‹

›› YOU HAVE ABOUT ENOUGH GLASS FOR TWO, AND THAT WAY YOU COULD EACH WORK ON A DIFFERENT CHANDELIER. AND THEN WHEN YOU GET IT UP, GET IT PHOTOGRAPHED, DOWN IT COMES, AND THEN UP AGAIN. ‹‹

›› AND YOU KNOW HAVE FUN WITH IT. REALLY CUT LOOSE AND TRY THINGS. AND YOU MIGHT EVEN HAVE STUFF COMING OUT OF THE MIDDLE, YOU KNOW. GET SOME OF THOSE BIG ICICLES COMING OUT OF THE MIDDLE, GOING STRAIGHT UP IN THE AIR. ‹‹

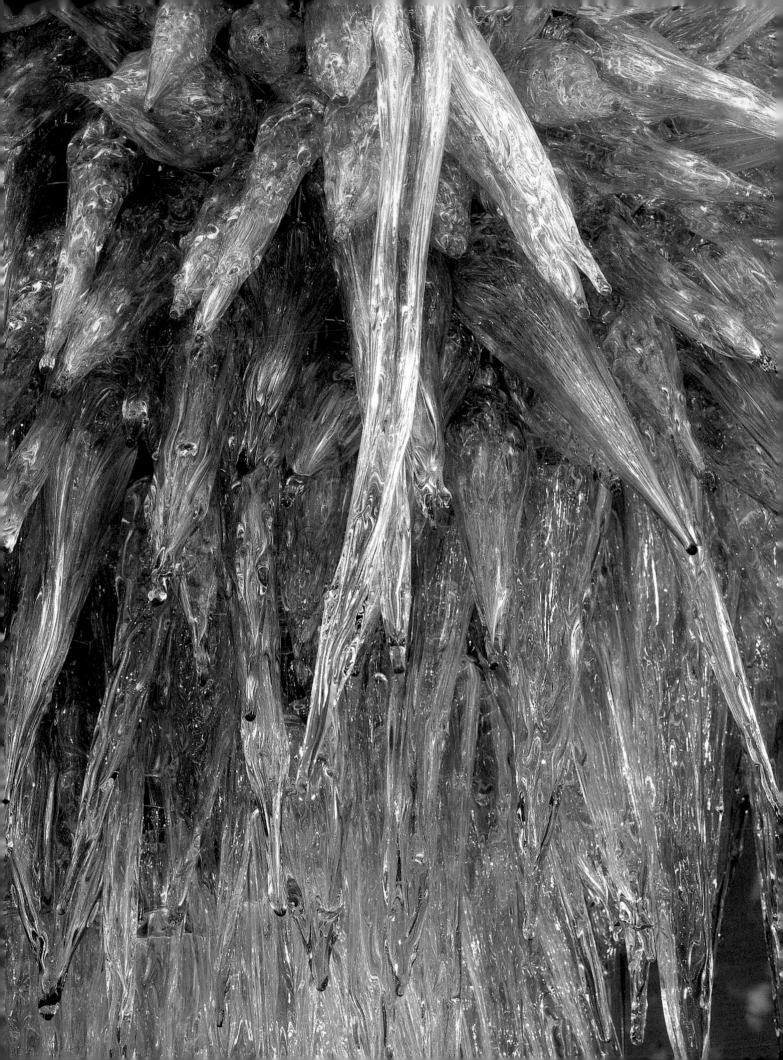

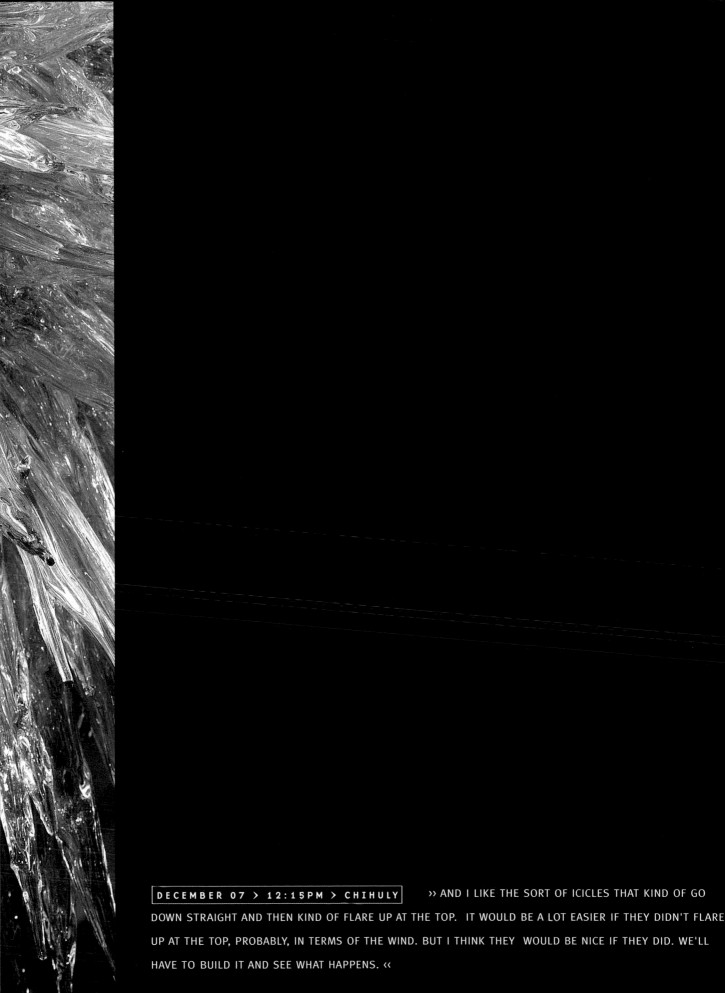

›› AND I LIKE THE SORT OF ICICLES THAT KIND OF GO DOWN STRAIGHT AND THEN KIND OF FLARE UP AT THE TOP. IT WOULD BE A LOT EASIER IF THEY DIDN'T FLARE UP AT THE TOP, PROBABLY, IN TERMS OF THE WIND. BUT I THINK THEY WOULD BE NICE IF THEY DID. WE'LL HAVE TO BUILD IT AND SEE WHAT HAPPENS. ‹‹

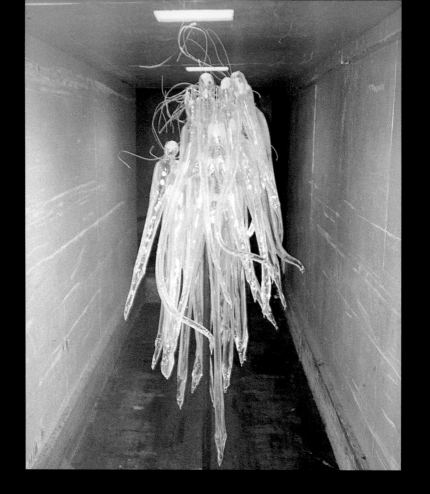

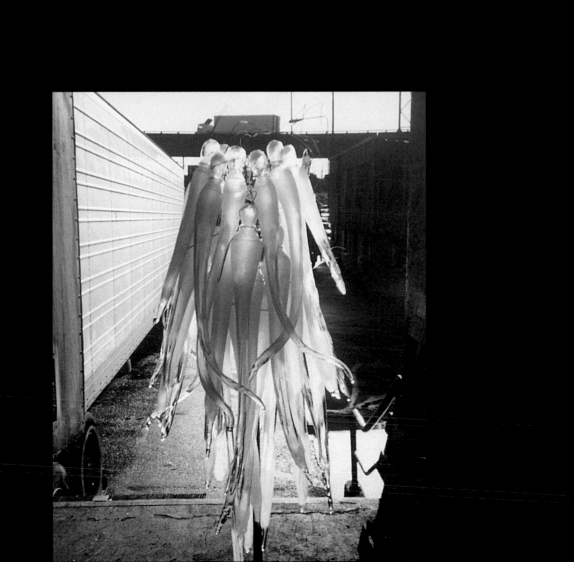

Dear Harriet & Warren

So glad you were happy
with the "Chandelier of Ice"
and 30 people working on
your chandelier for 3 weeks
nonstop. They loved
it & they did an extraordinary
piece so true forever in
the woods of Leavenworth
on Icicle Creek. Can't
wait for the sun.
31,000' over the Pacific. Love Chihuly

›› SO THEY'RE
GOING TO THINK WE'RE NUTS OVER THERE, AND OF COURSE WE ARE A
LITTLE NUTS, BUT WE'LL GET THIS THING BUILT. ‹‹

>> OUR BIGGEST PROBLEM — EVERYBODY KEEPS TALKING ABOUT THE SNOWFALL AND HOW MUCH SNOWFALL THERE IS. CAN'T WE JUST ASSUME THAT IT COULD SNOW THERE AS HARD AS IT COULD ANYWHERE IN ANY GIVEN PERIOD OF TIME? BECAUSE THE MEDIAN SNOWFALL DOESN'T MAKE ANY DIFFERENCE AS FAR AS I CAN TELL. IT'S ONLY HOW MUCH SNOW COULD HAPPEN IN WORST-CASE CONDITIONS, WHICH I WOULD THINK WOULD BE PRETTY HEAVY. <<

>> SO THIS NEW ARMATURE WE DESIGNED, THE SNOW GOES THROUGH IT. THERE WILL BE A HEATER AT THE END OF THE PIPE TO USE ELECTRIC HEAT, MAYBE 50 AMPS OR SO, WHEN WE NEED IT. IF WE EVER NEED IT. <<

>> SO WE HAVE TO COME UP WITH SYSTEM THAT'S PROTECTED, THAT ENOUGH BTU'S TO REALLY MELT THIS THINK THAT WOULD BE IN THE NEIG DON'T KNOW, A MILLION BTU'S OR COURSE, YOU WOULD NEVER USE THA UNLESS YOU NEEDED TO. <<

>> THE IDEA OF THE HOT AIR IS TO KEEP THE SNOW FROM STICKING TO THE ELEMENTS. AND THEN ALSO, IF WATER GETS ON IT, IT WILL FREEZE AND MAKE ICICLES. IT WOULD BE NICE TO BE ABLE TO REGULATE THAT SO WE COULD MAKE IT AS ICICLY OR AS NON-ICICLY AS WE WANTED TO, ACCORDING TO THE TEMPERATURE OF THE AIR, PERHAPS, OR PERHAPS THE AMOUNT OF AIR. <<

>> AND THEN WE'LL FIGURE OUT THE COMPLICATIONS AND HOW TO GET A ROD INTO THE ROCK. KAI, YOU WORK ON A CORE DRILLER TO FIND OUT HOW IT WOULD BE TO CORE DRILL THAT THING, WHETHER IT'S GRANITE OR WHATEVER. I WOULD ASSUME YOU WOULD PUT IT IN WITH A LITTLE BIT OF SLOP AND THEN SHIM IT WITH SOMETHING. MAYBE YOU SHIM IT WITH A SOFT METAL LIKE LEAD. I'M NOT SURE. HARRIET WOULDN'T LIKE LEAD ON THE PROPERTY. <<

>> I THINK WE SHOULD LIGHT IT EXTERIORLY AS USUAL FROM DIFFERENT LOCATIONS. SOME OF THEM MIGHT HAVE TO BE QUITE A WAYS AWAY, SO WE MIGHT WANT SOME HIGH-POWERED SPOTS. AT LEAST THE AIRCRAFT LANDING LIGHTS, IF NOT EVEN STRONGER. <<

ADIANT HEAT
THROW OFF
OW. I WOULD
ORHOOD OF, I
METHING. OF
JLL QUANTITY,

>> IT SOUNDS LIKE THINGS ARE JUST GOING GREAT. WONDERFUL. IT'S GOT MORE PIECES THAN I THOUGHT, BUT WE MIGHT AS WELL MAKE IT A 1000-PART PIECE, NOW THAT YOU'RE UP TO 994. <<

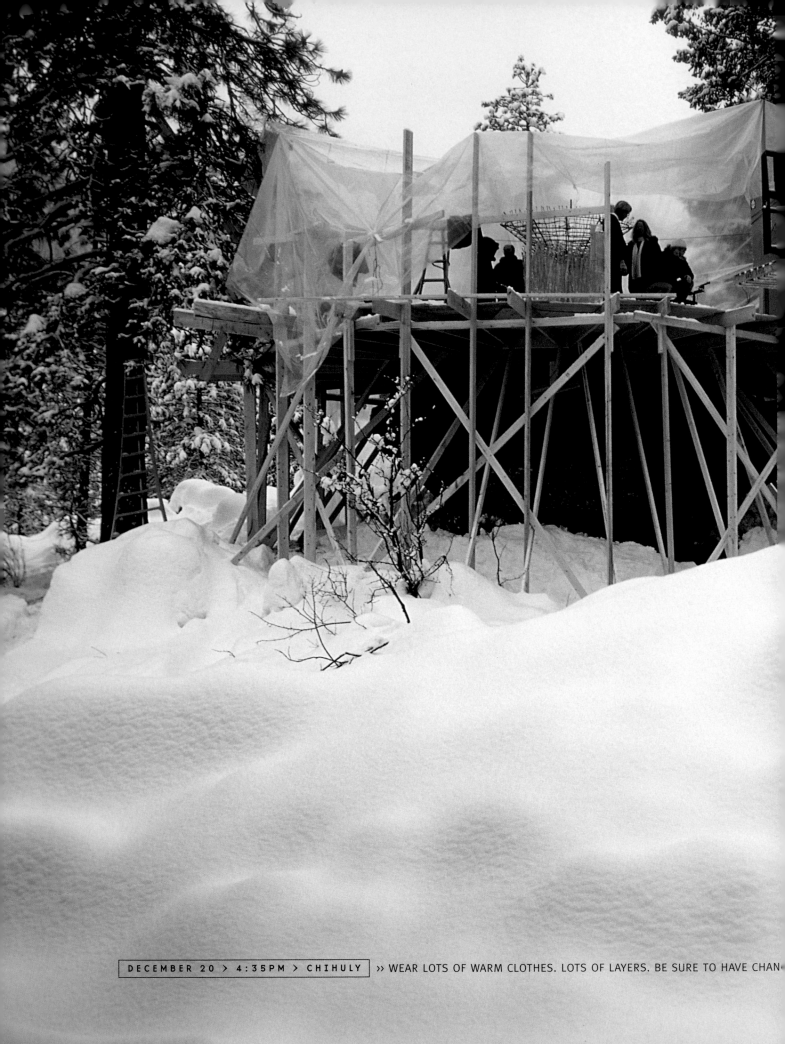

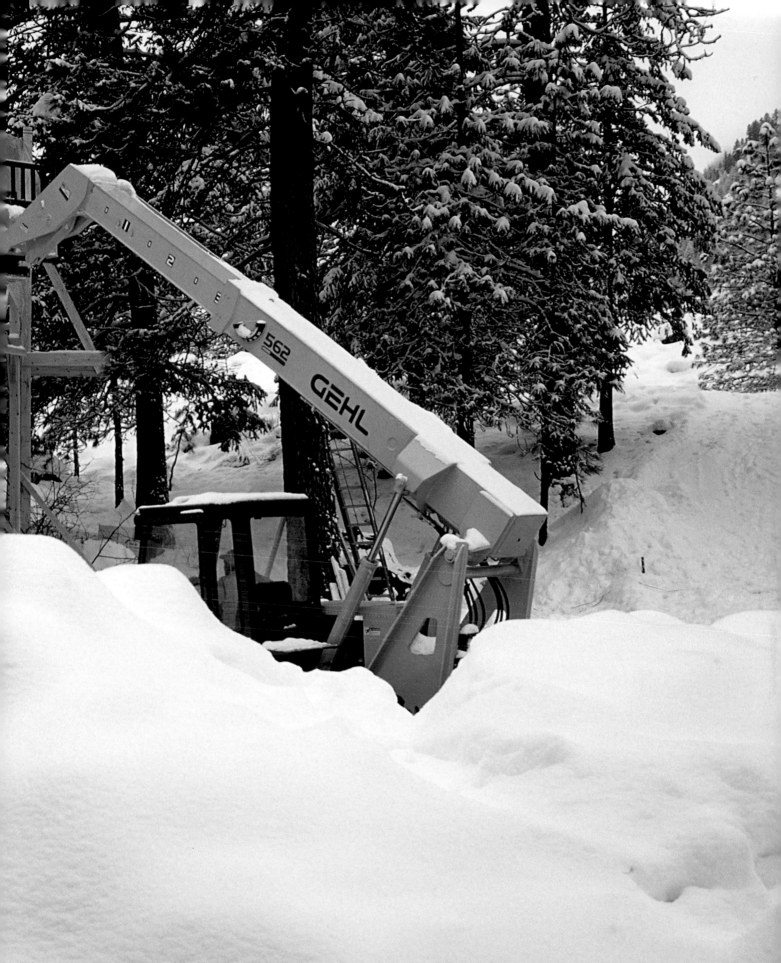

LOVES. I ALWAYS LIKE THOSE THIN WOOL GLOVES. LOTS OF STOCKING CAPS. GET YOUR GOODIES. HAVE A GREAT TIME. REPORT IN. «

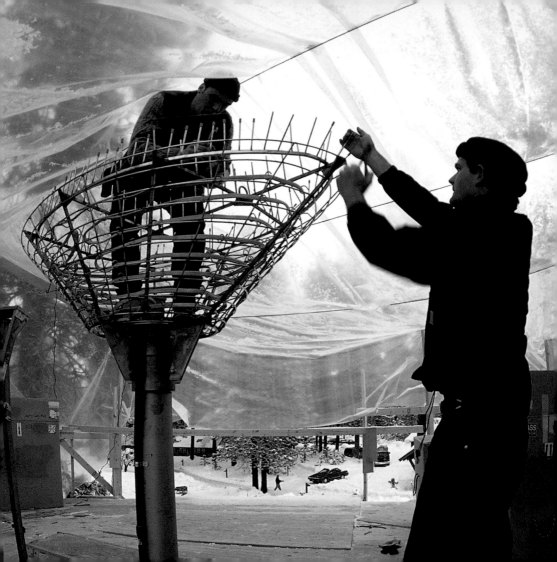

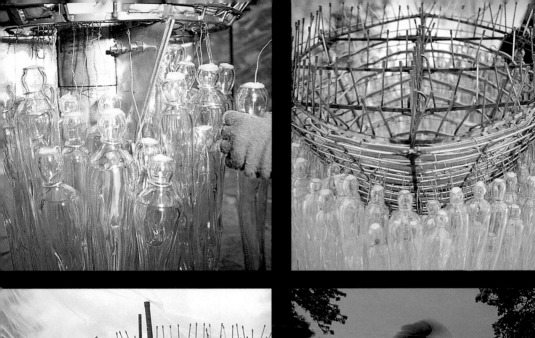
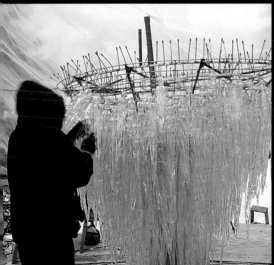
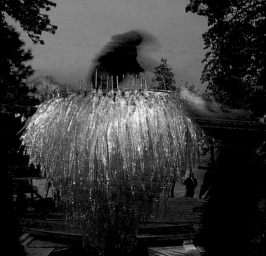

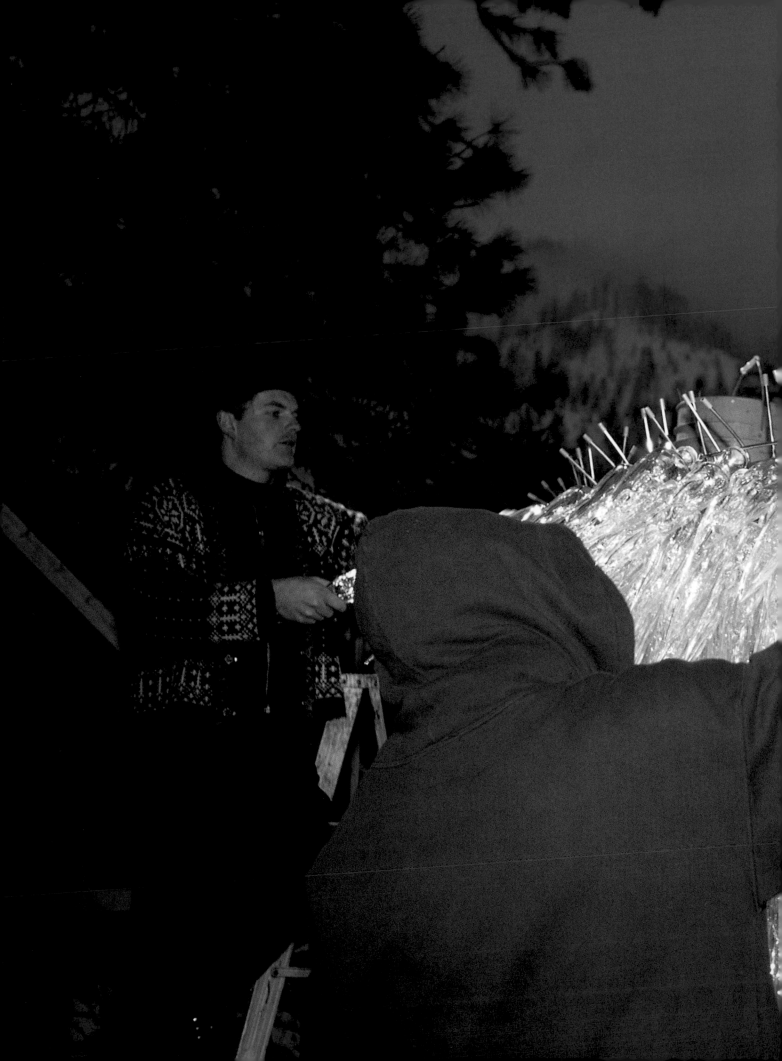

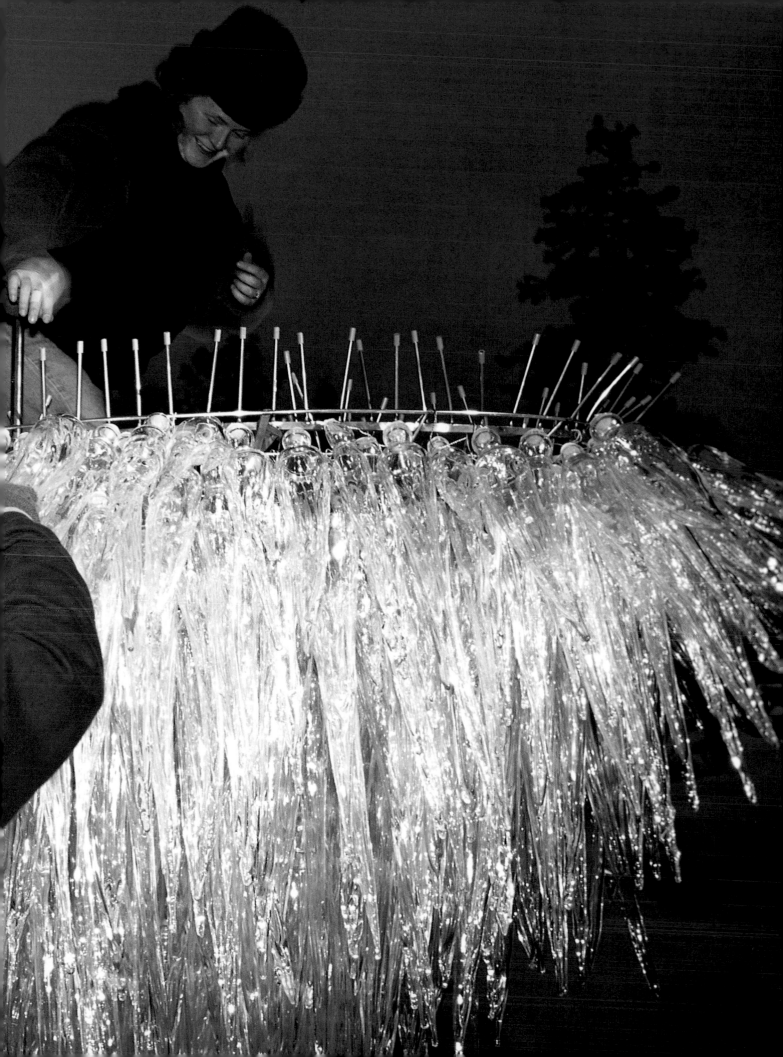

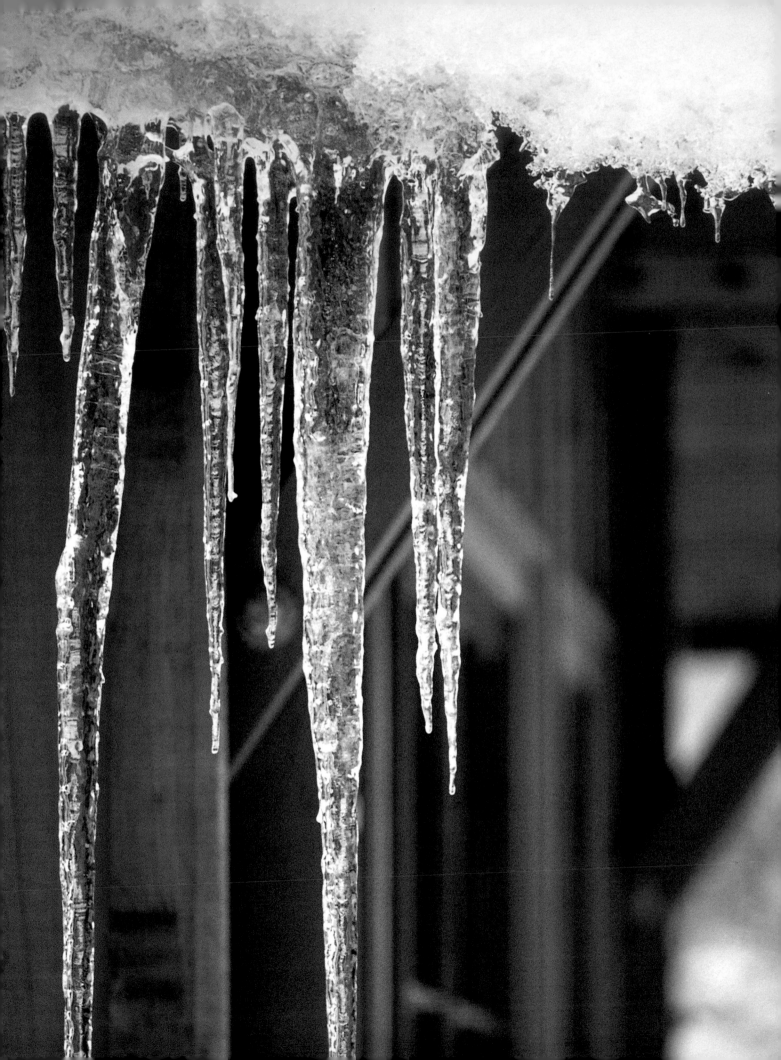

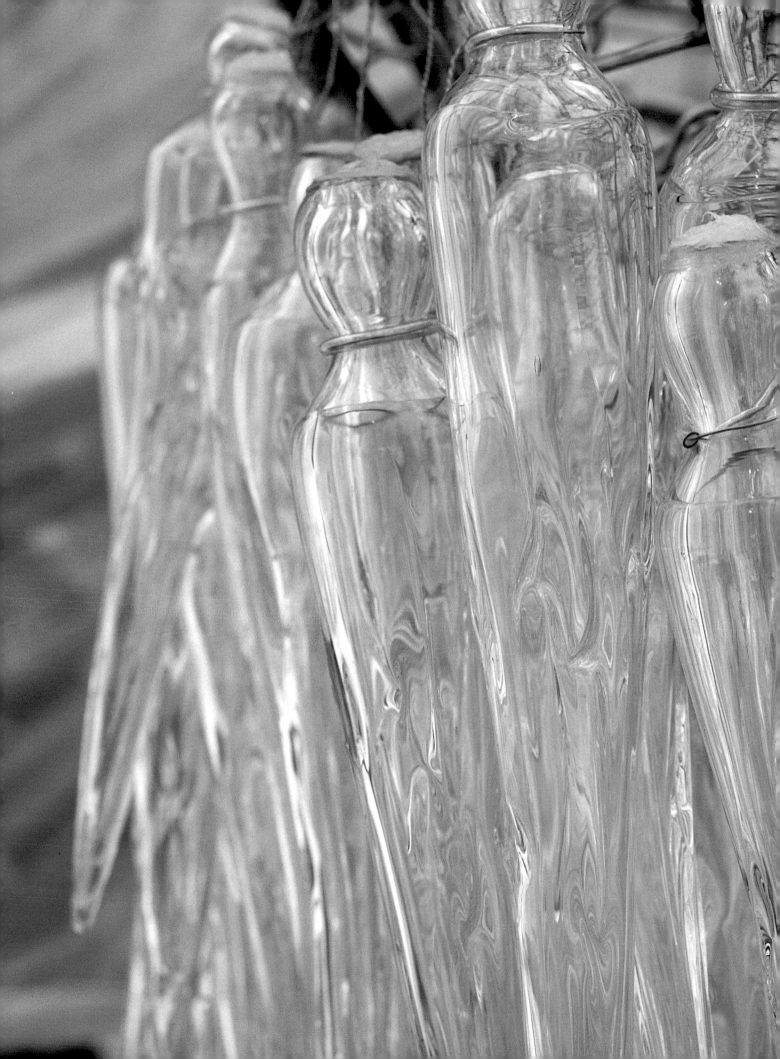

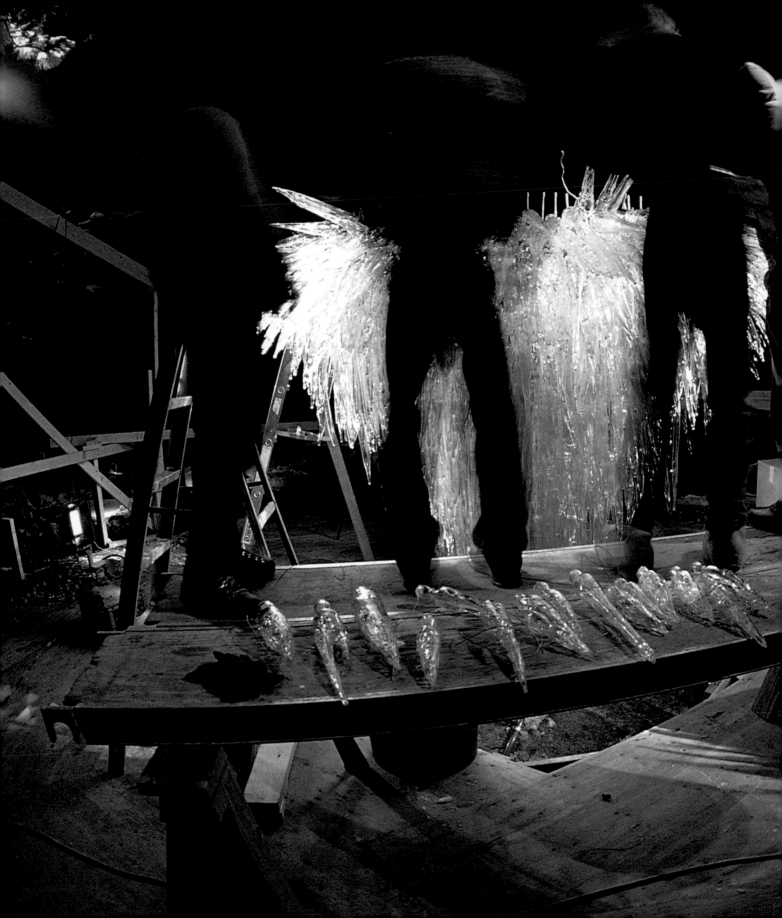

›› BUT KEEP IN MIND – PARKS, LANDON, KAI, WHOEVER IS PUTTING THIS UP – WHEN IN DOUBT, YOU KNOW, BE A LITTLE LOOSE WITH IT! OKAY. DON'T GET IT TOO TIGHT. IT'S ALREADY A HEAVY PIECE. AND WHEN IN DOUBT, DON'T MAKE IT TOO DENSE. ‹‹

» WOULD YOU SEND ME A LIGHTING DIAGRAM, JEFF, A

LIGHTING PLAN, OF SOME OF YOUR CONCEPTS HERE? YOU KNOW, IF YOU COULD FAX IT TO ME HERE AT THE RITZ HOTEL

AT WHERE AM I? KANSAS? OR IF THAT COULD BE FAXED TO ME ON MONDAY MORNING. I THINK I LEAVE HERE SOME-

THING AROUND LIKE 2:00 P.M. YOUR TIME ON MONDAY. «

| DECEMBER 17 > 11:51AM > CHIHULY | » HEY PARKS, CHIHULY, COMING IN FROM O'HARE, GOING

OUT TO TOKYO, COMING BACK ON THE 23RD. THE ONLY THING THAT WORRIES ME NOW IS LIGHTING, AND I'M SURE JEFF

CAN GET THAT TOGETHER. I WOULD LIKE IT ON A DIMMER, SO THAT HARRIET CAN DIM IT. YOU KNOW, GET FIVE, SIX,

SEVEN, EIGHT, NINE LIGHTS ON THERE AND I THINK THEY SHOULD BE PAR 64'S, COMING IN FROM THE TREES. I DO NOT

WANT TO SEE THESE FIXTURES DOWN BELOW THIS SCULPTURE UNLESS SOMEBODY'S GOT A REAL GOOD IDEA WHY. AND

I CAN'T WAIT TO SEE IT. YOU KNOW I GUESS I WON'T SEE IT UNTIL THE DEDICATION. «

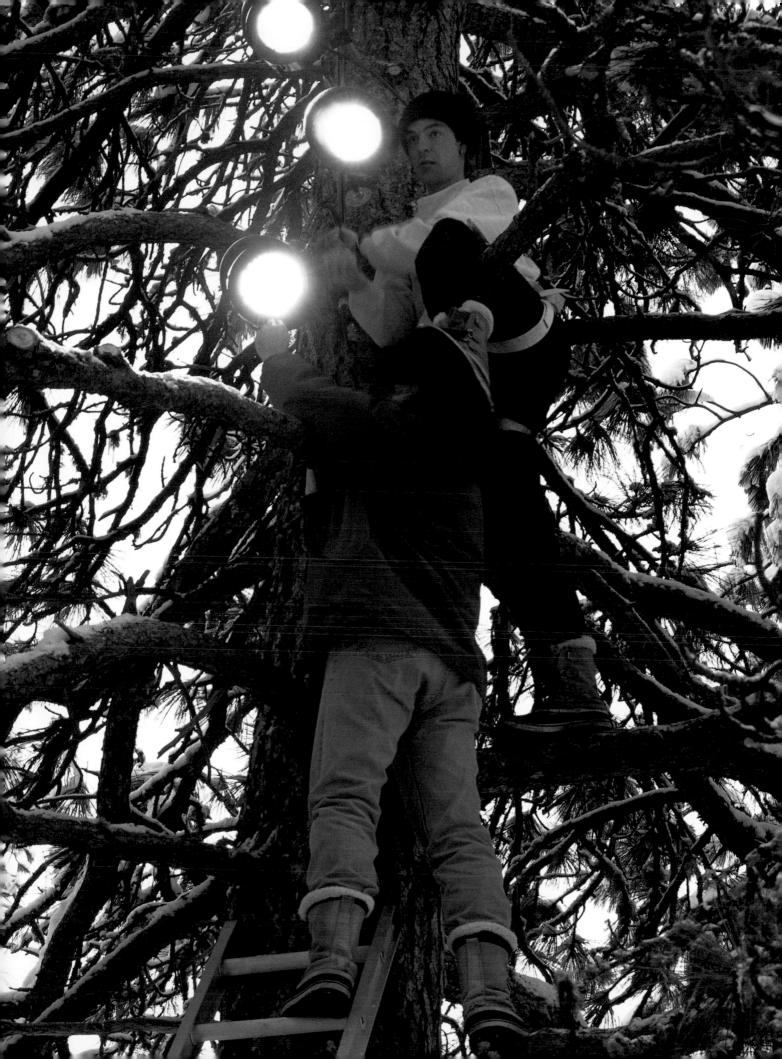

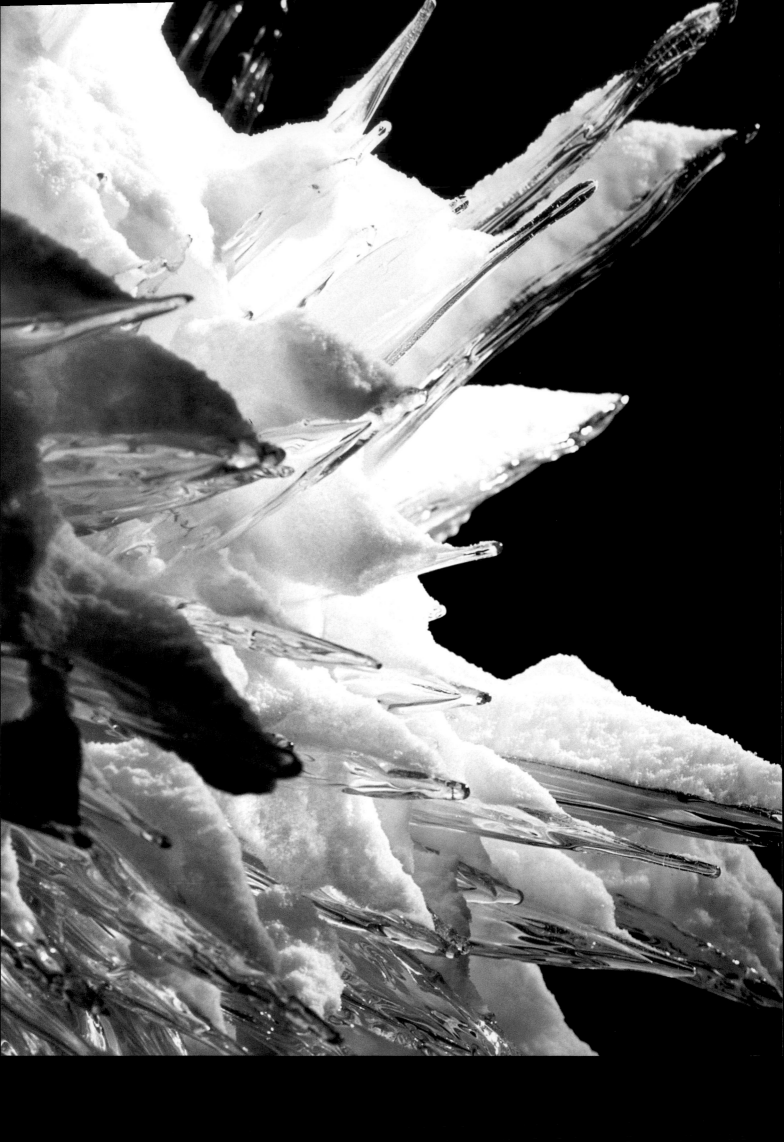

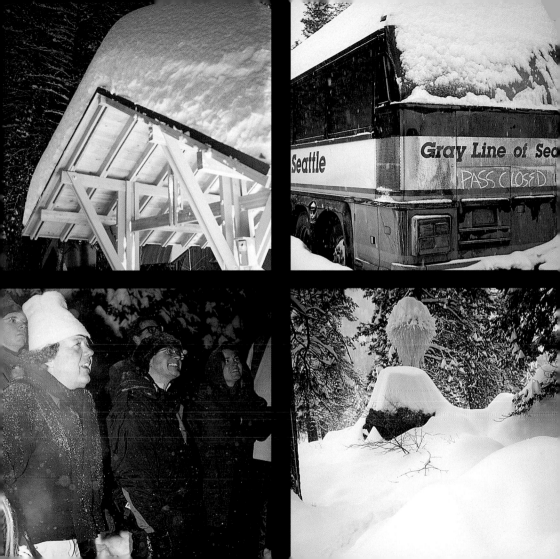

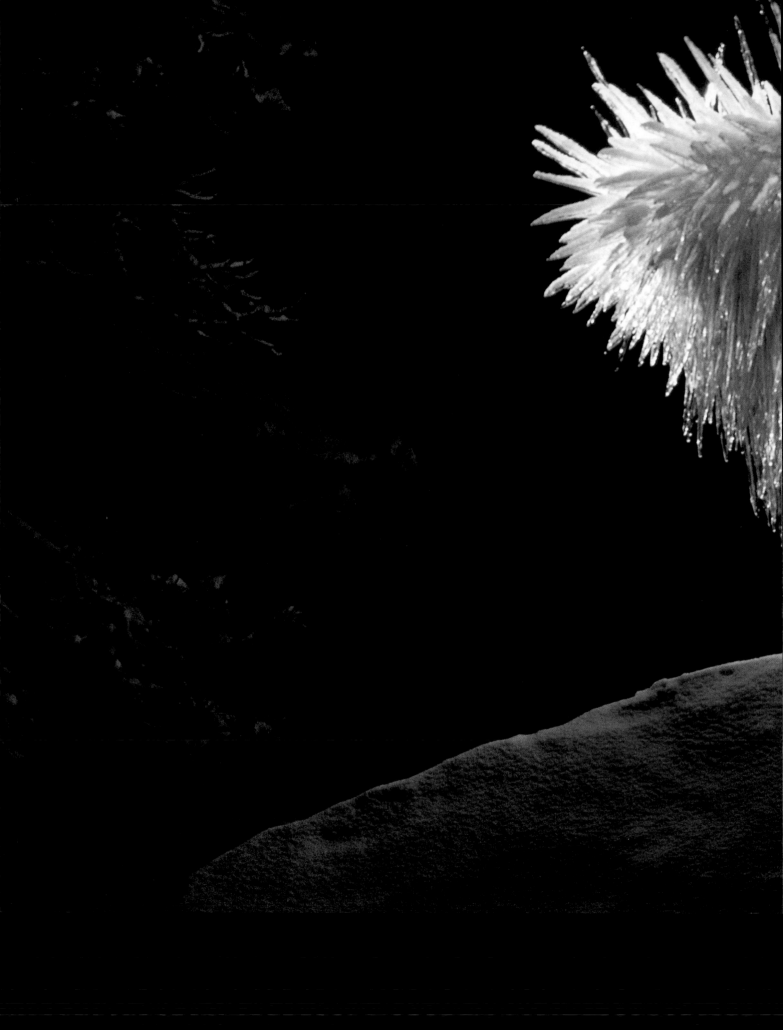

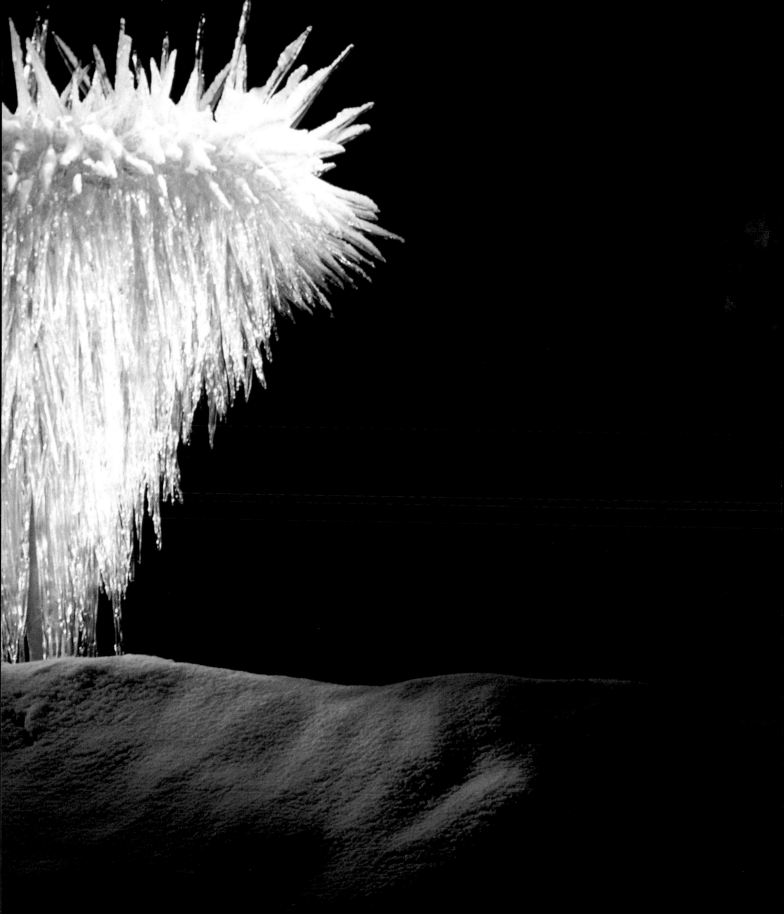

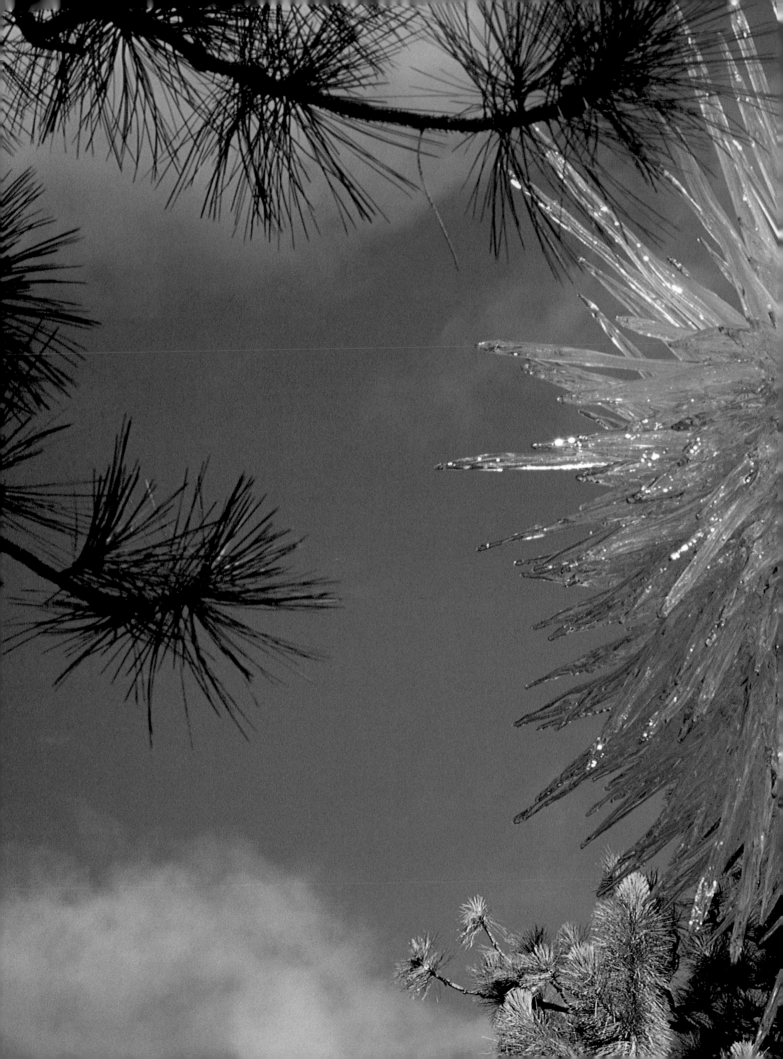

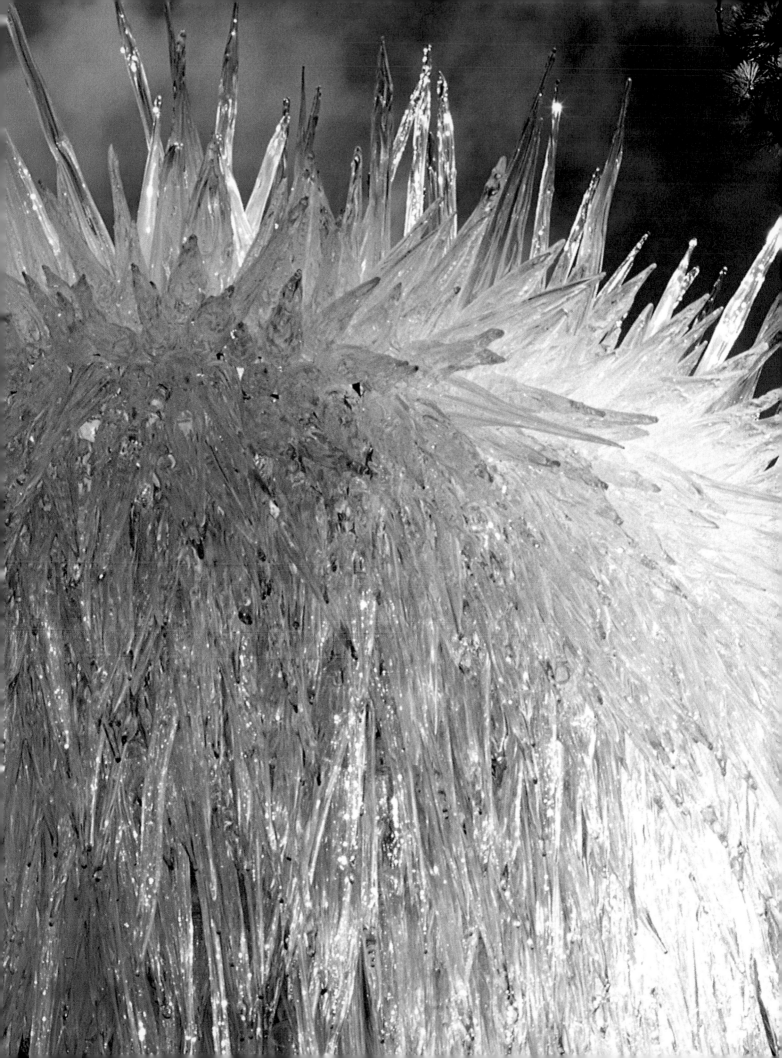

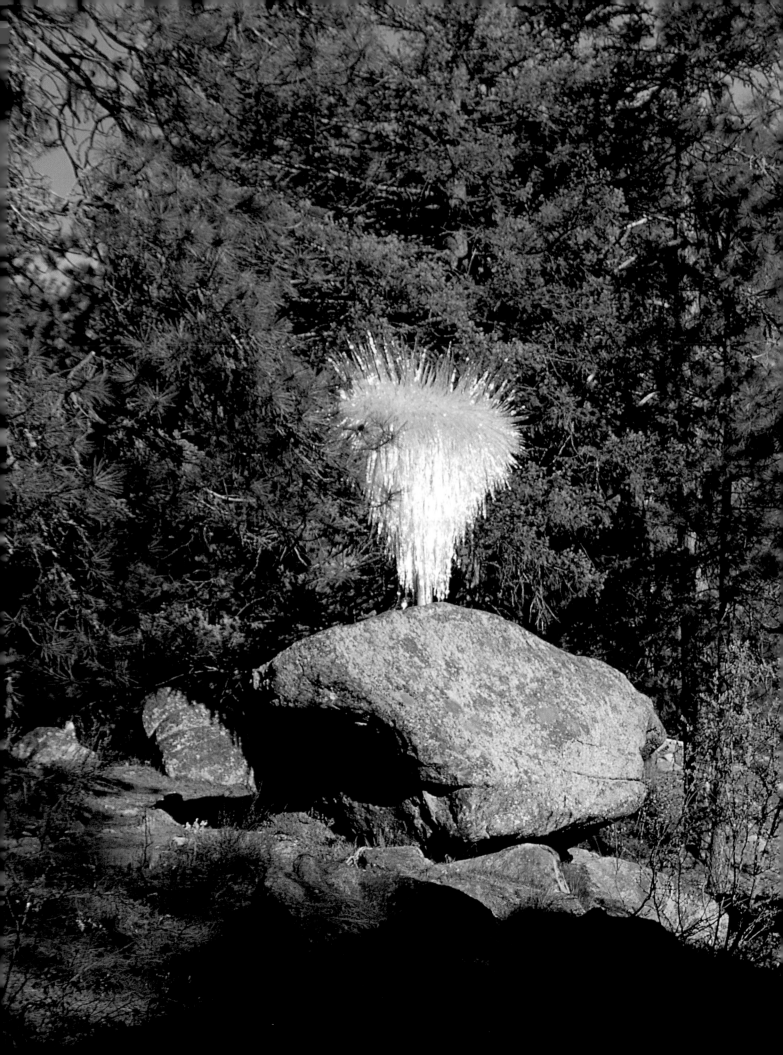

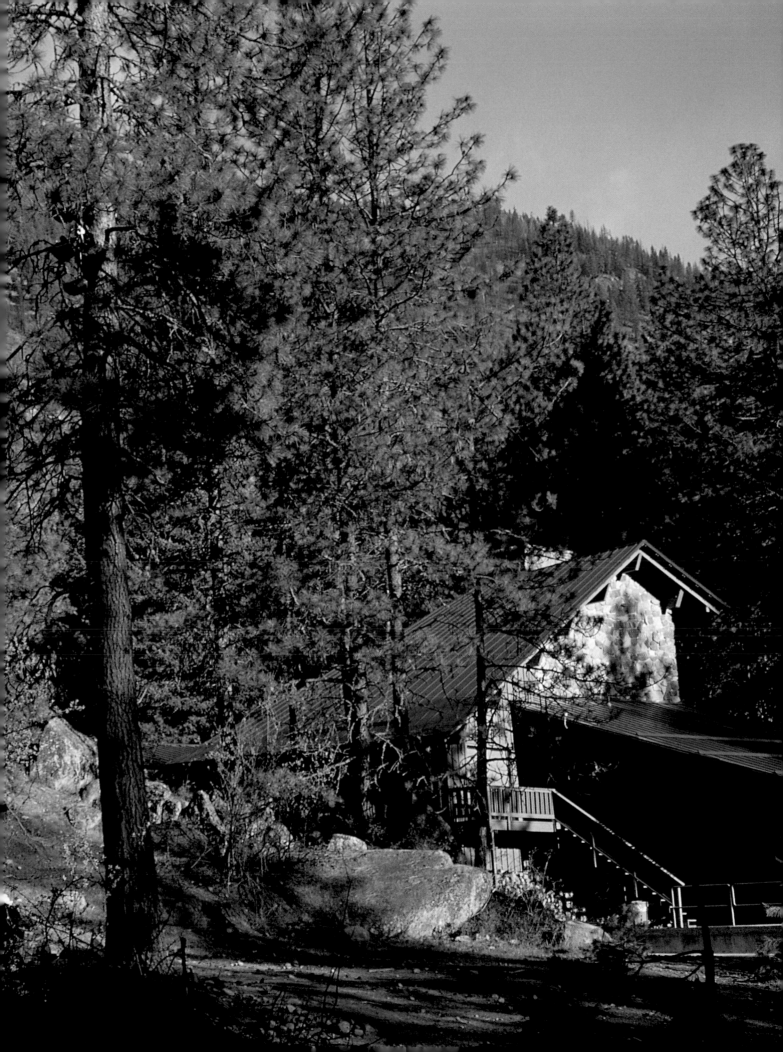

Thanks Everybody
for making the Sleeping
Lady project
ICICLES GREEK CHANDELIER
into one of the most extra-
ordinarily installed glass
we've ever built.

love
Chihuly

37000' en route
Prague-Bilbao

<GLASSBLOWERS> SCOTT ALBA, JOHN BENNETT, RYAN BLYTHE, J. P. CANLIS, PAT DAVIDSON, JOEY DeCAMP, PAUL DeSOMMA, BRUCE GREEK, BENNETT JORDAN, JOHN KILEY, CLAY LOGAN, JIM MONGRAIN, BOB PARK, ERIC PAULI, ANNETTE RINGE, ASHLEY ROWLEY, DAN SPITZER

<INSTALLATION> PARKS ANDERSON, ERIC AUGINO, JEFF BENDER, MARK BENNETT, MARIT BERG, KAI-UWE BERGMANN, ROGER BRANSTEITTER, MICK CALNAN, DANIEL ENDERLE, JEFF GERBER, MANISONE GIPSON, EVA GOODMAN, NOELLE HIGGINS, JOHN LANDON, EILEEN LANNAN, TOM LIND, TOM McHUGH, DENNIS PALIN, D.J. PALIN, CHARLIE PARRIOTT, GREG PIERCY, RICK RISHEL, TERESA RISHEL, TERRY RISHEL, JOE ROSSANO, PAULA STOKES, ALLEN VINUP, KRISTEN WIRE, THOMAS YORK

<CONSULTANTS> BOYER ELECTRIC, CHALKER PUTNAM COLLINS SCOTT (ENGINEERING), CHARLES WATTS COMPANY (CONSTRUCTION), CONSTRUCTION SAWING DRILLING, FORD MOTOR COMPANY, GEM WELDING, ALEK JACKSON (FORESTER), DOUG KELBAUGH (SOLAR CONSULTANT), LINMARK STEEL, JEFF McCALLUM (LIGHTING), JOHN McKOY (ARBORIST), ANDY MOORE (GEOLOGIST), TOM PEARSALL (MATERIAL SCIENTIST), RAINIER COLD STORAGE, DICK STERN (HEATING)

<PHOTO CREDITS> SHAUN CHAPPELL, JONES & JONES, JOHN MARSHALL, TERESA RISHEL, TERRY RISHEL, ROGER TURK

» I MEAN, THIS SLEEPING LADY THING WAS
DONE, YOU KNOW, PRIMARILY THROUGH
VOICE MAIL, AND WE REALLY DIDN'T HAVE
MANY GLITCHES ALL THE WAY THROUGH.
I WOULD SAY THIS THING WENT VERY, VERY
SMOOTHLY, AND IT GOES TO SHOW WHAT
CAN BE DONE WITH VOICE MAIL. «